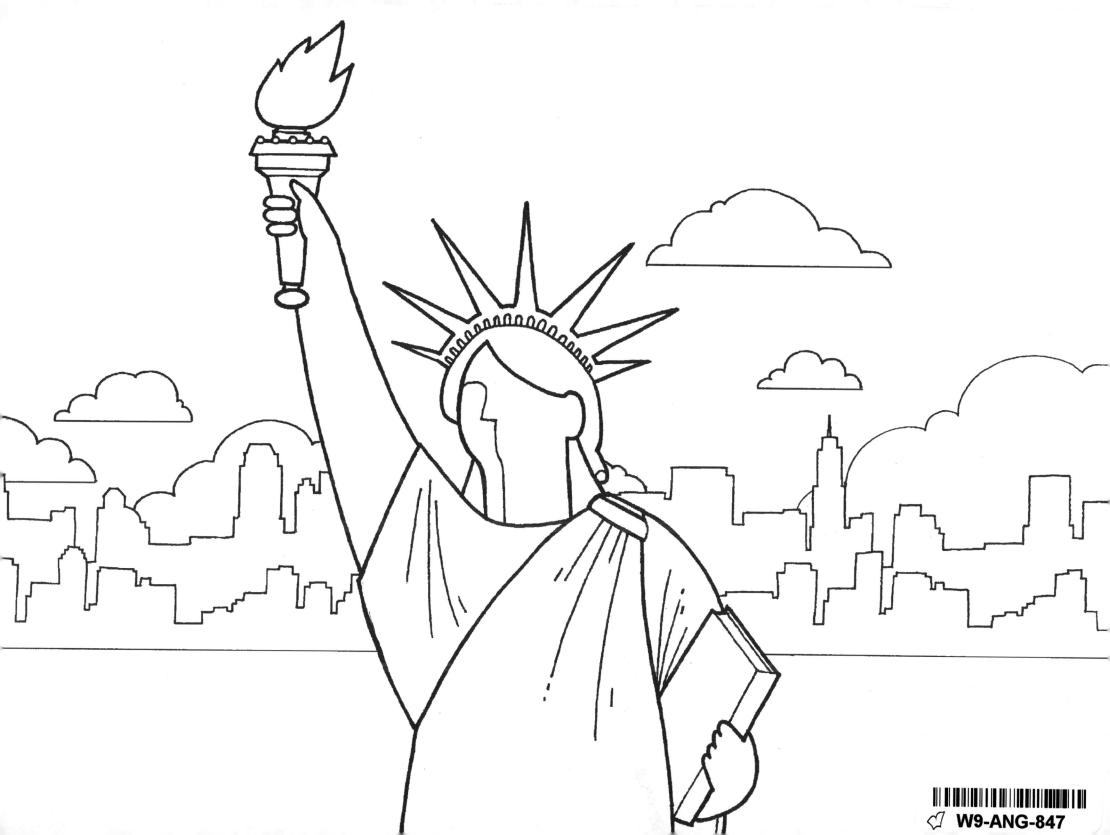

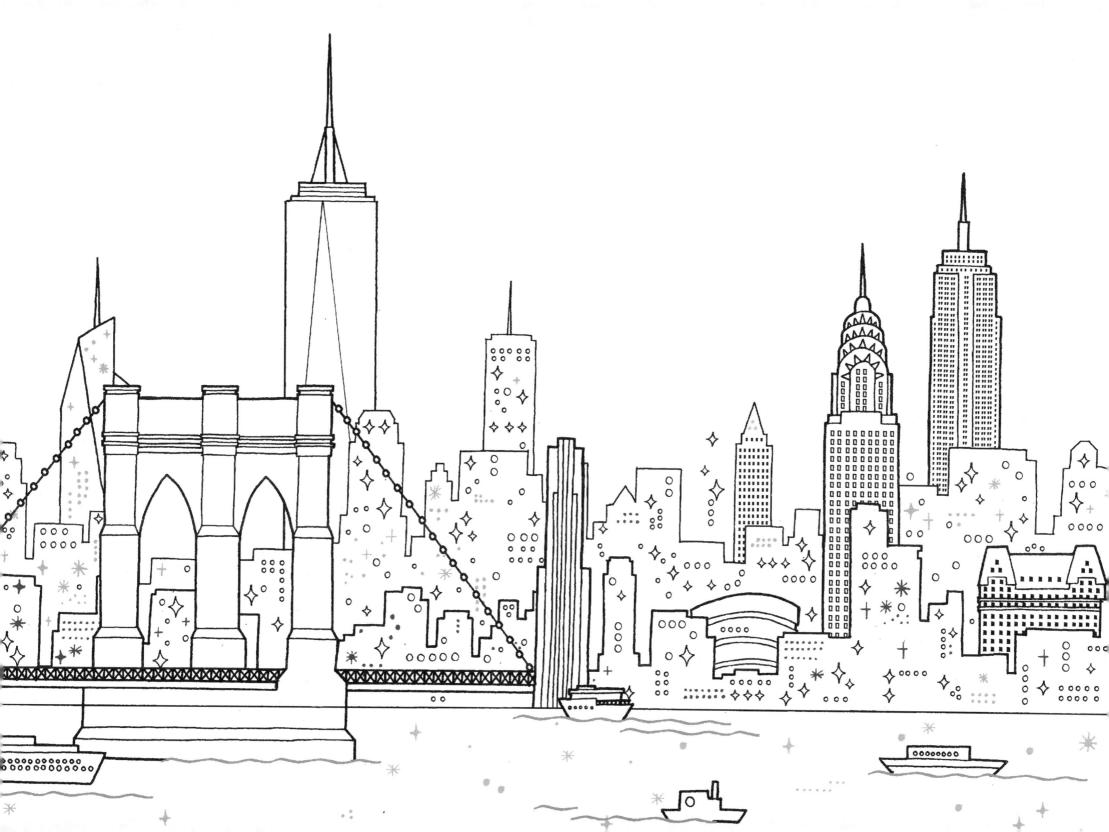

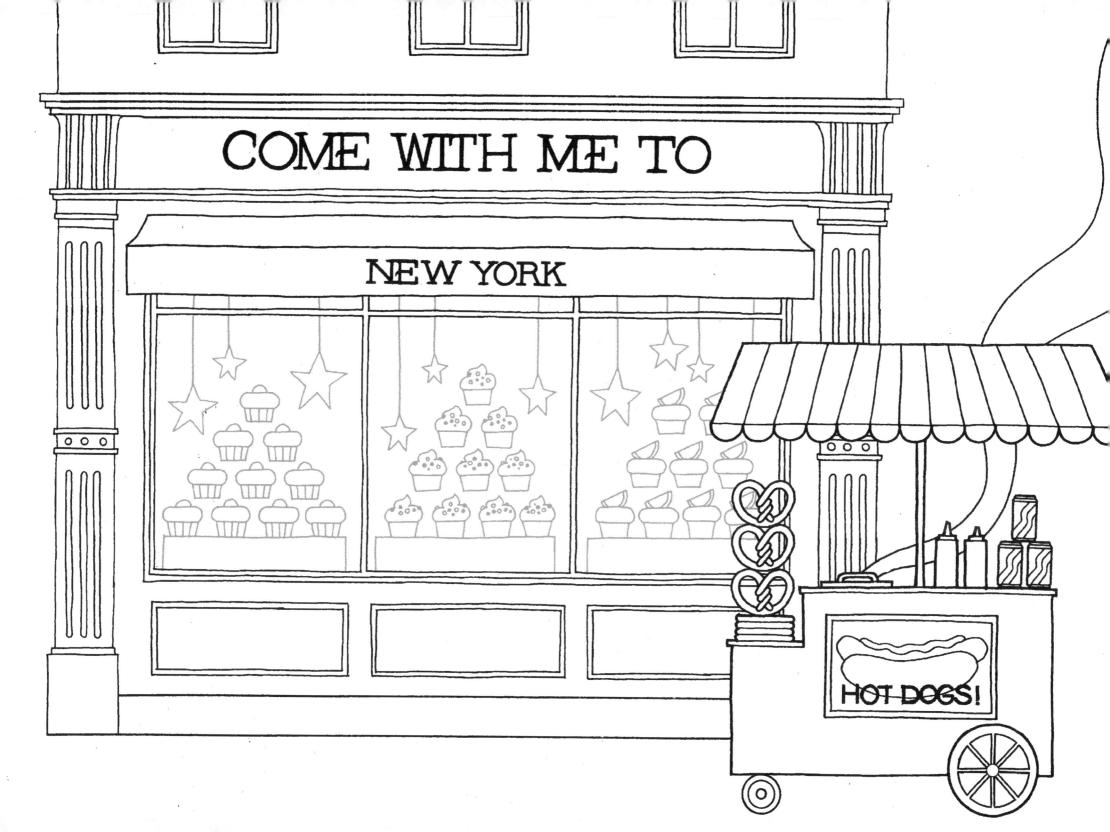

					14	Senation St.

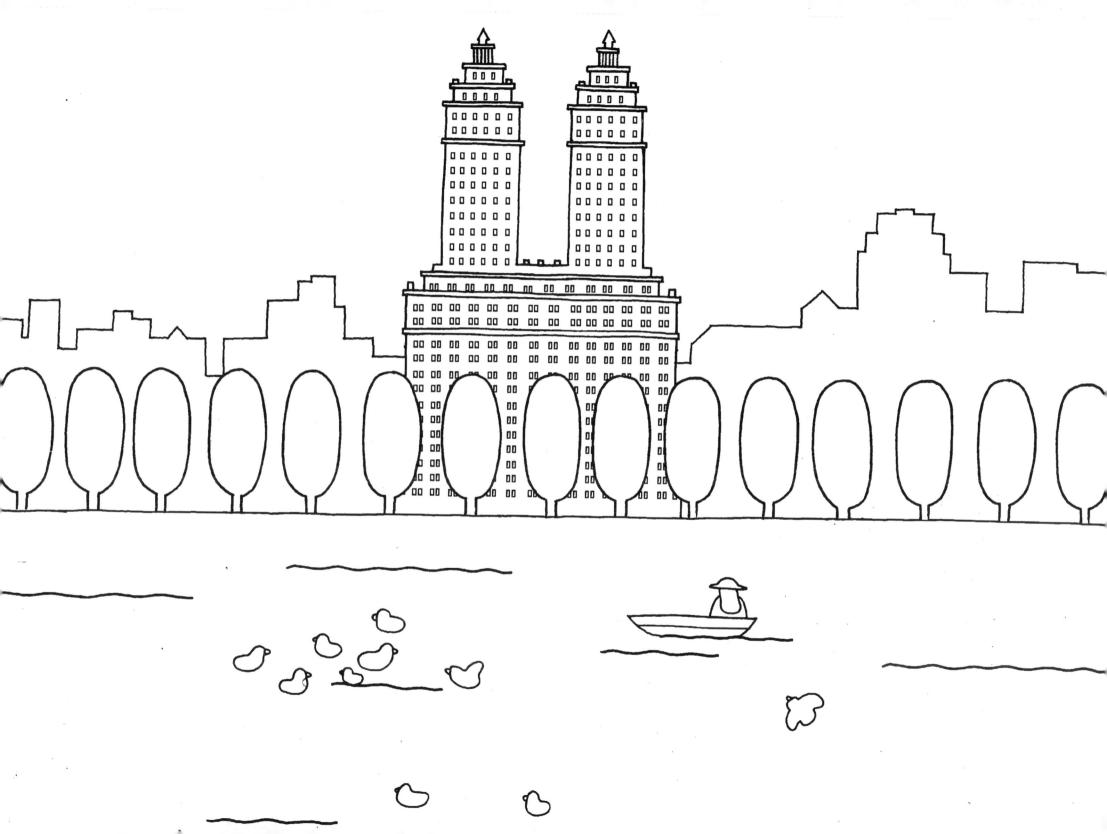

				ne man			

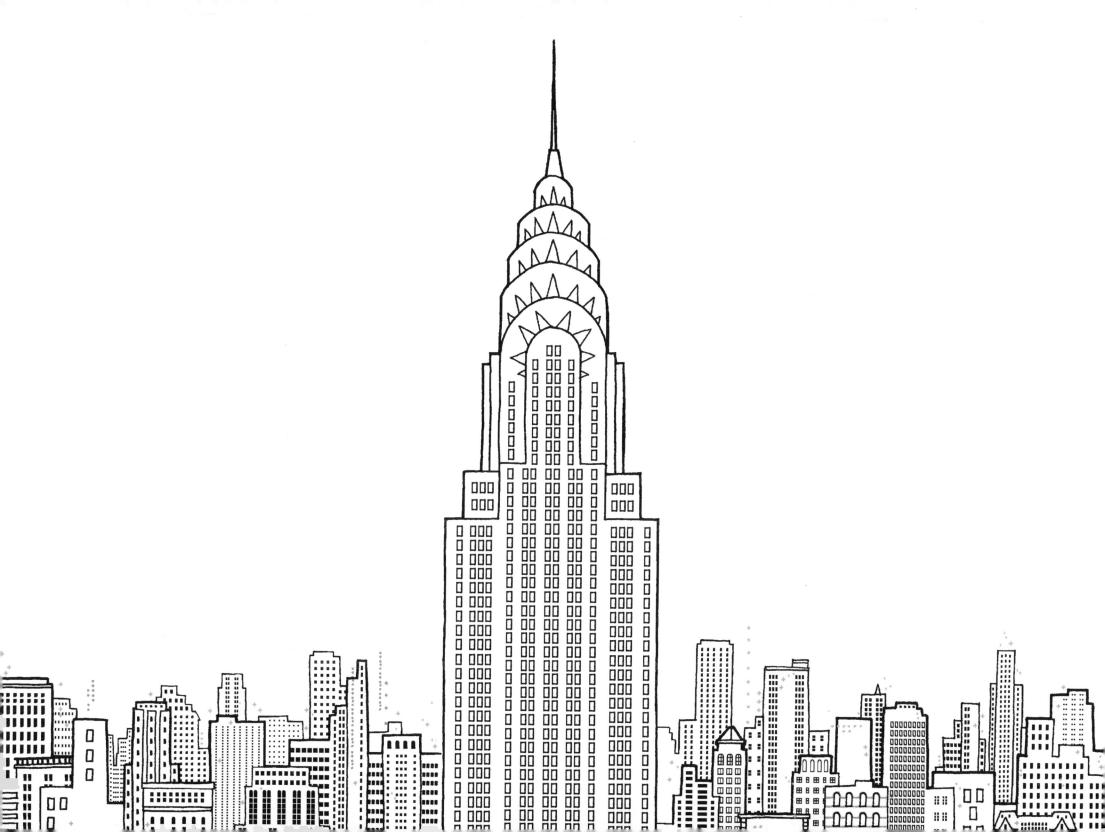

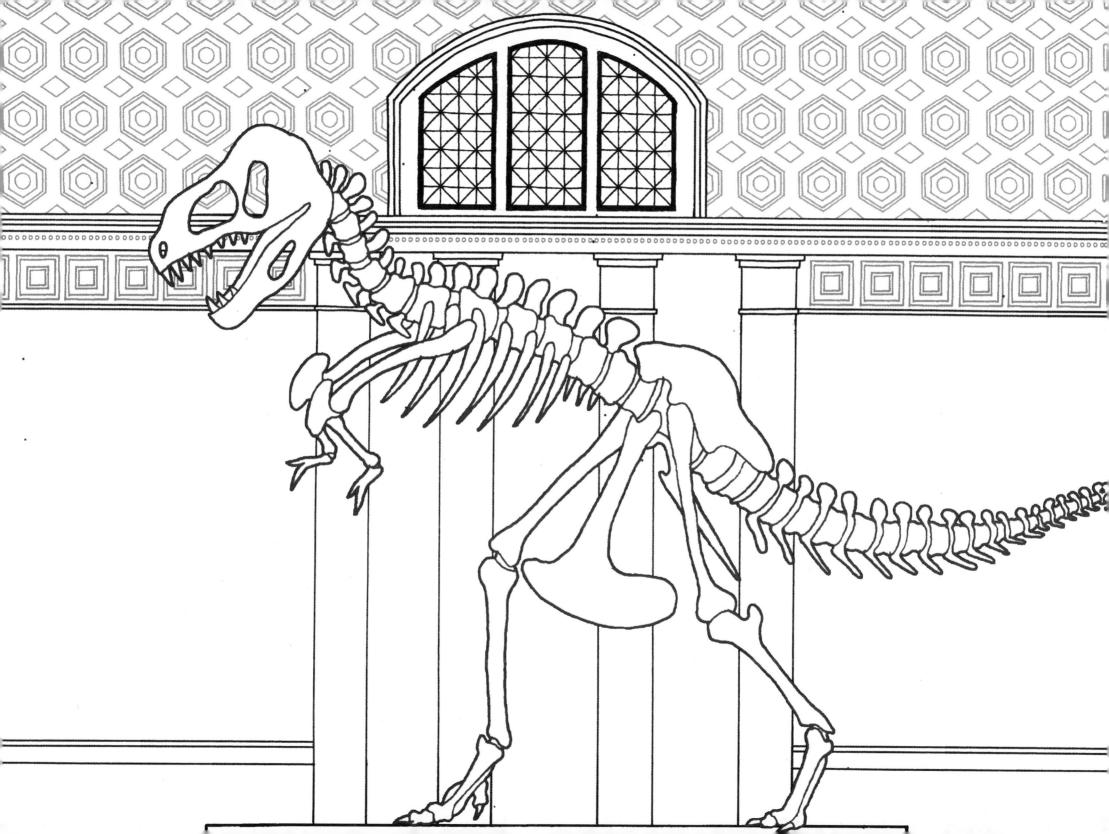

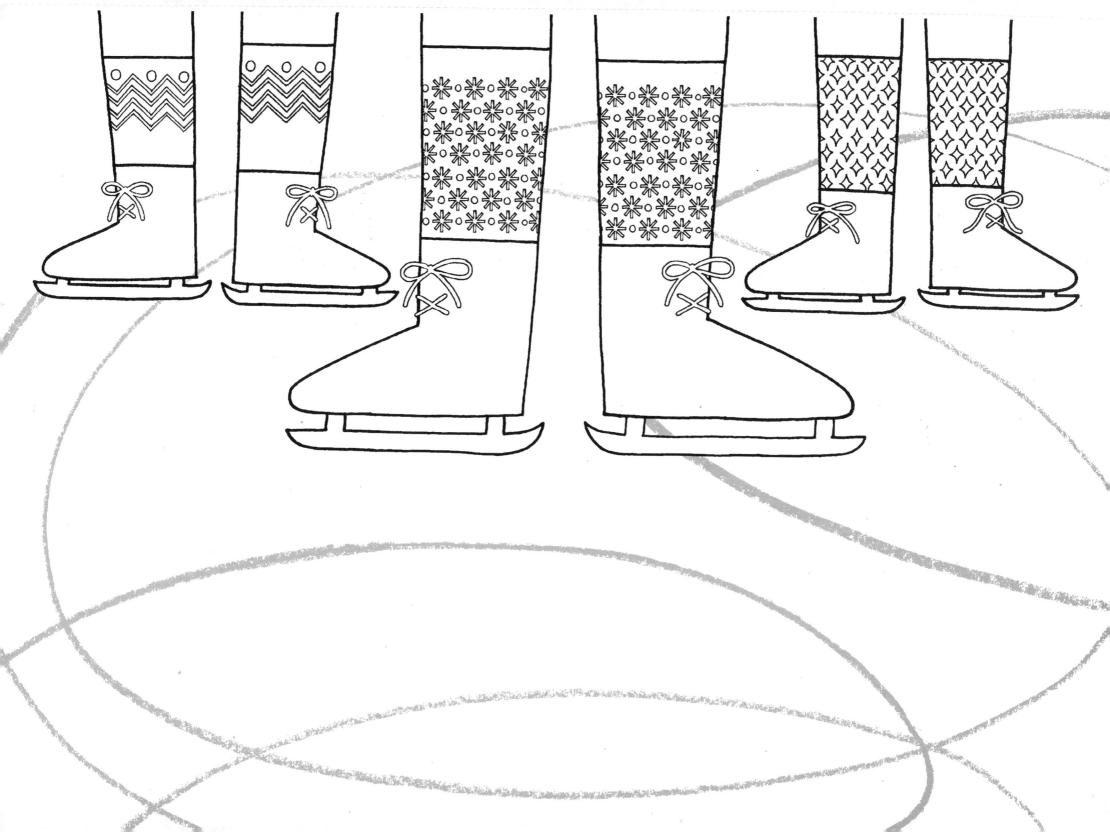

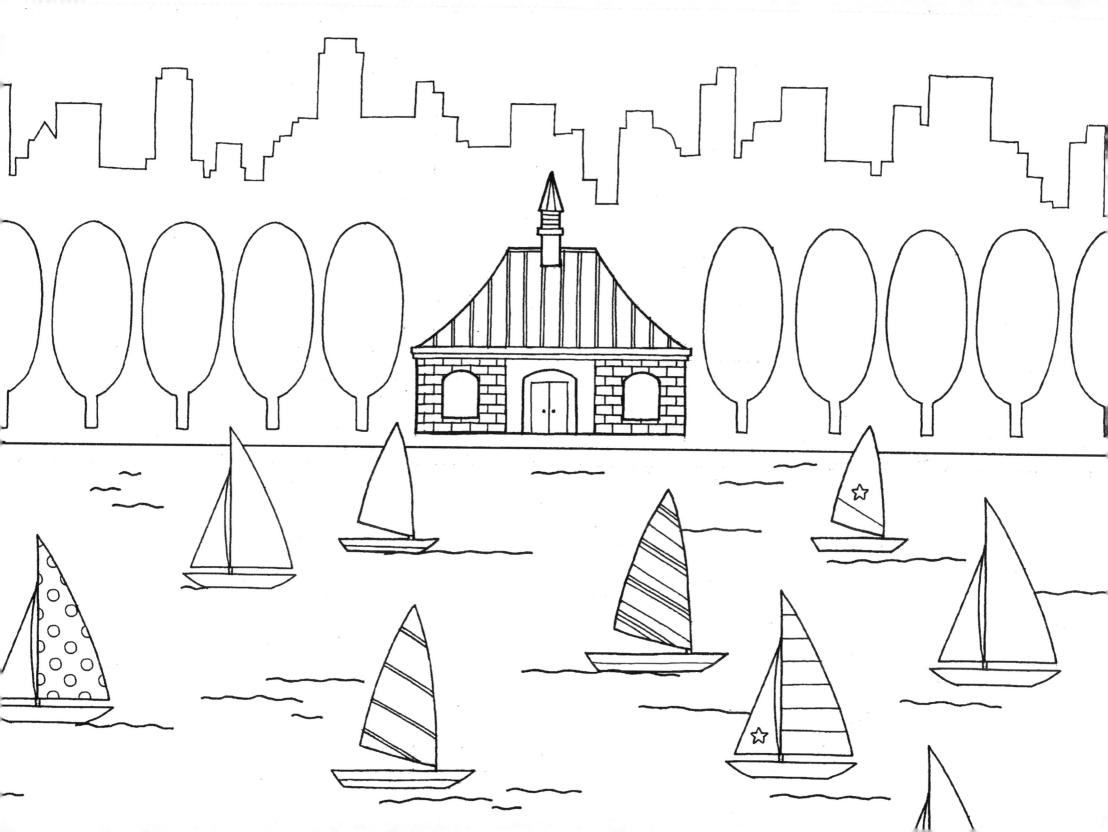

		74

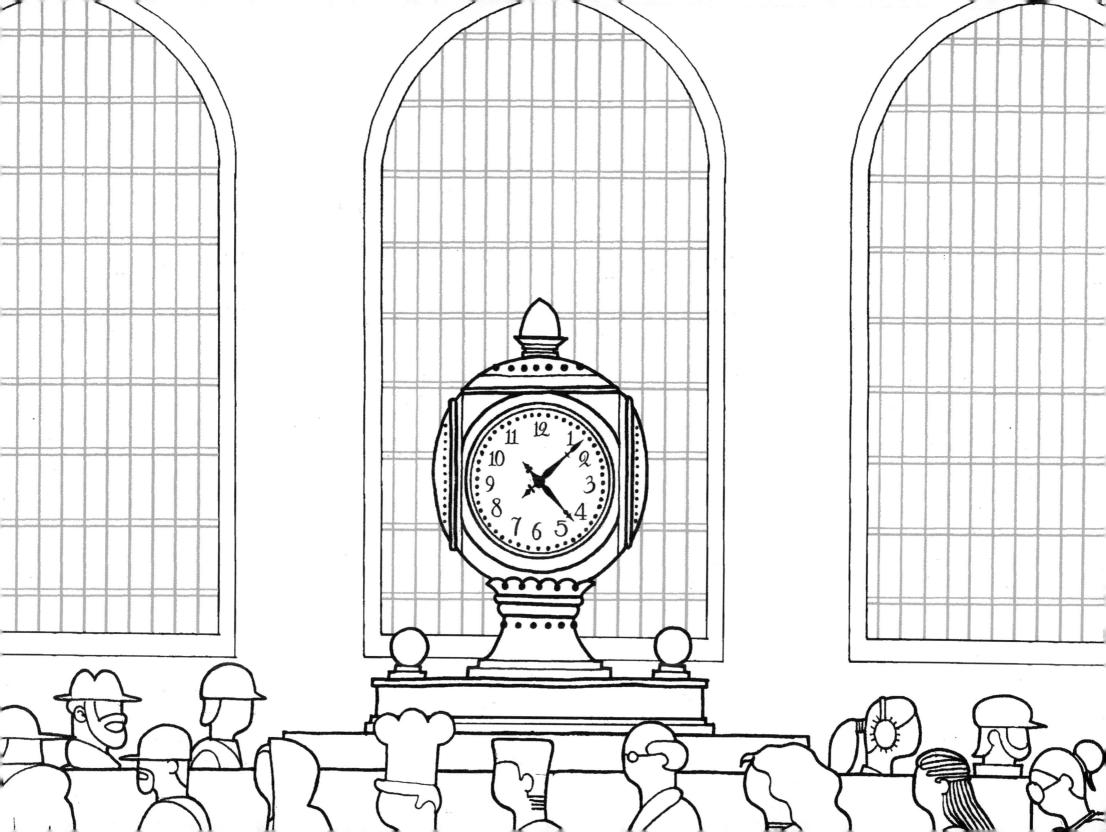

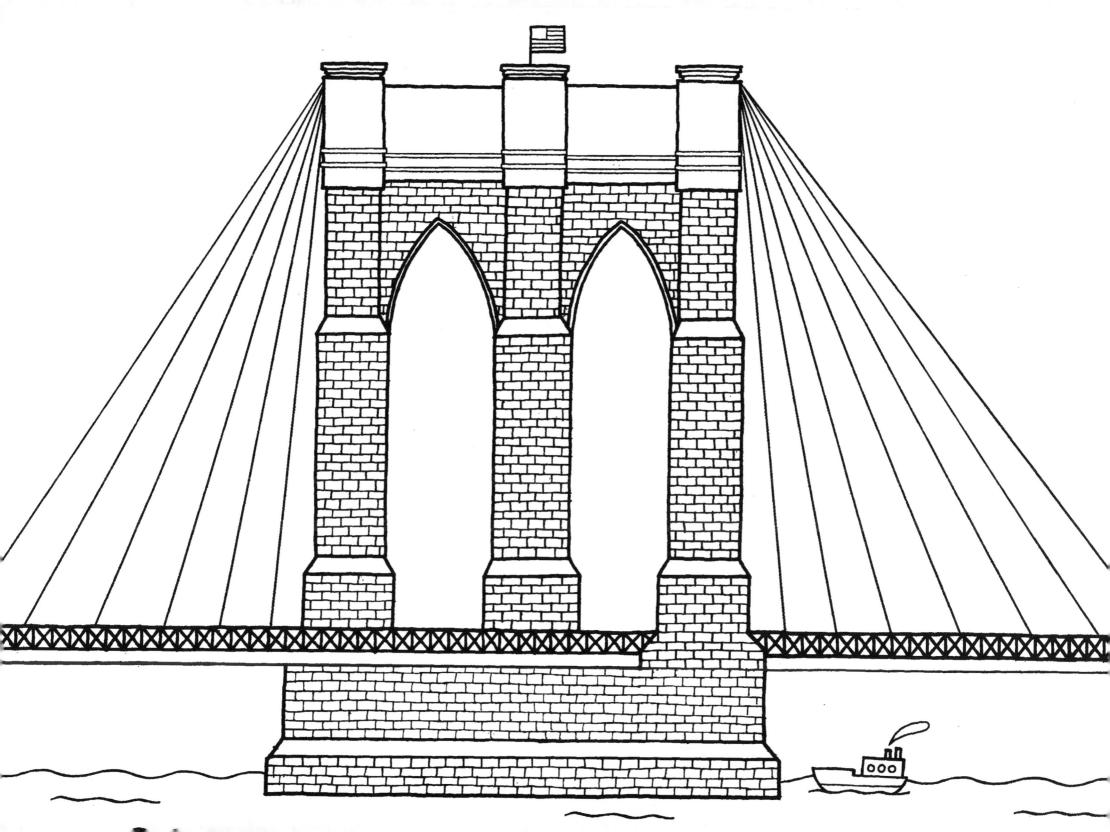

					•
			and the second	a appropriate transport to the service	100 A 100 A 100 A

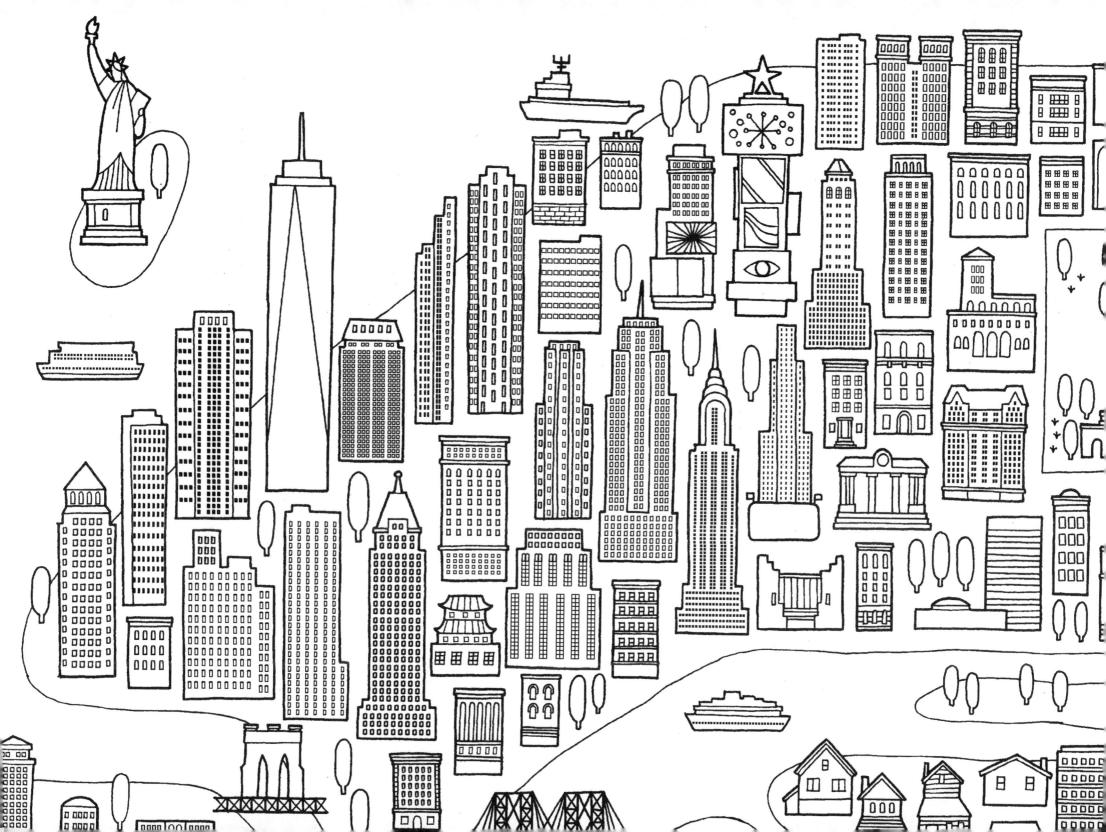

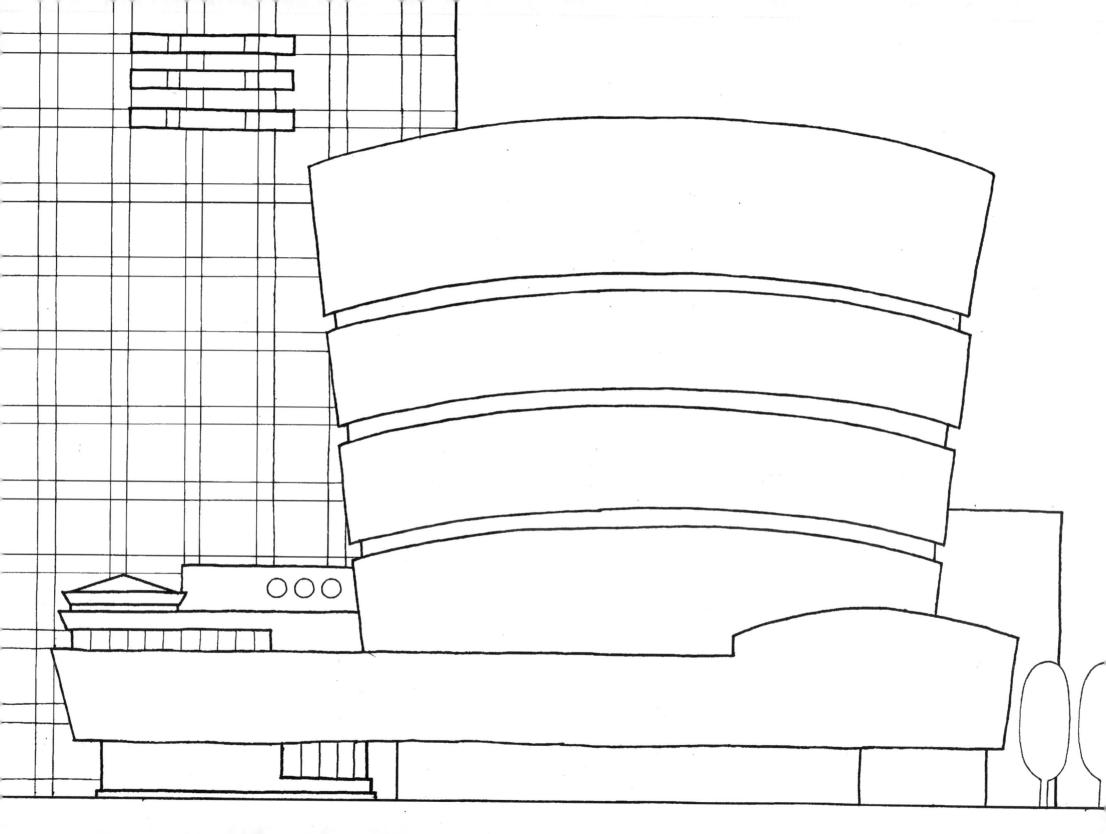

					de ar ar an	a spiritual april has

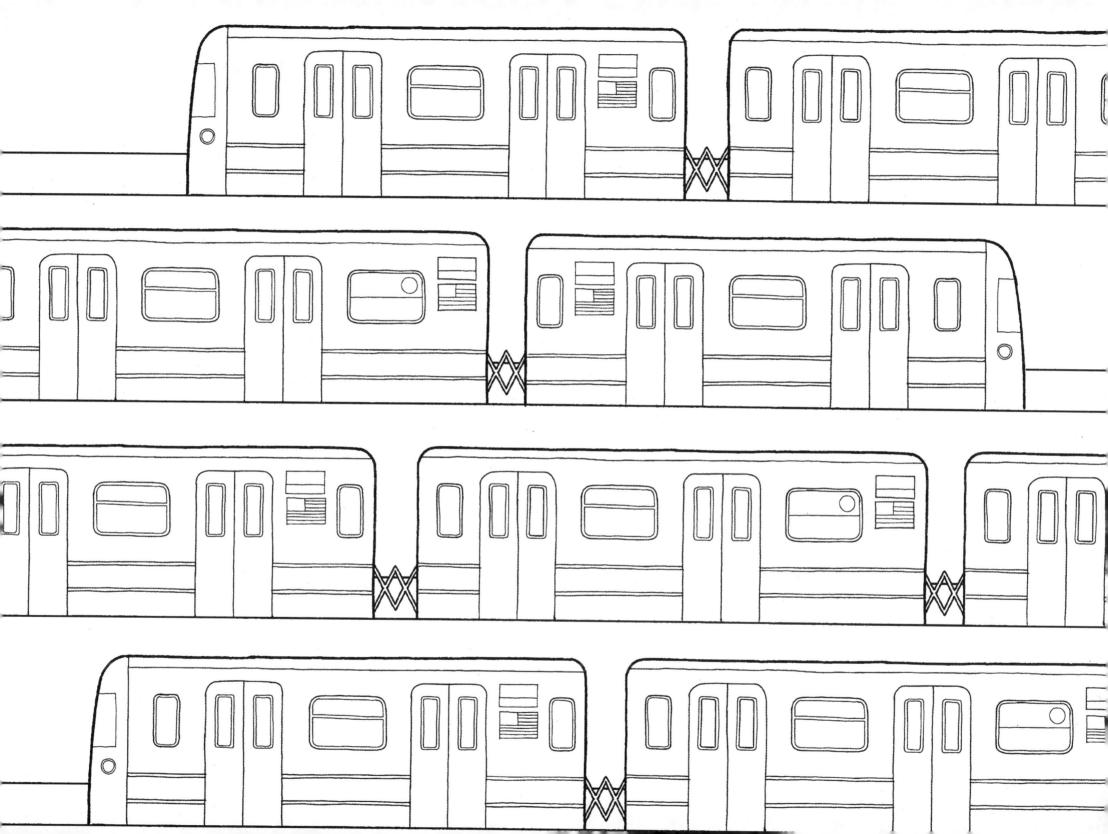

							140
					well statement to straig		

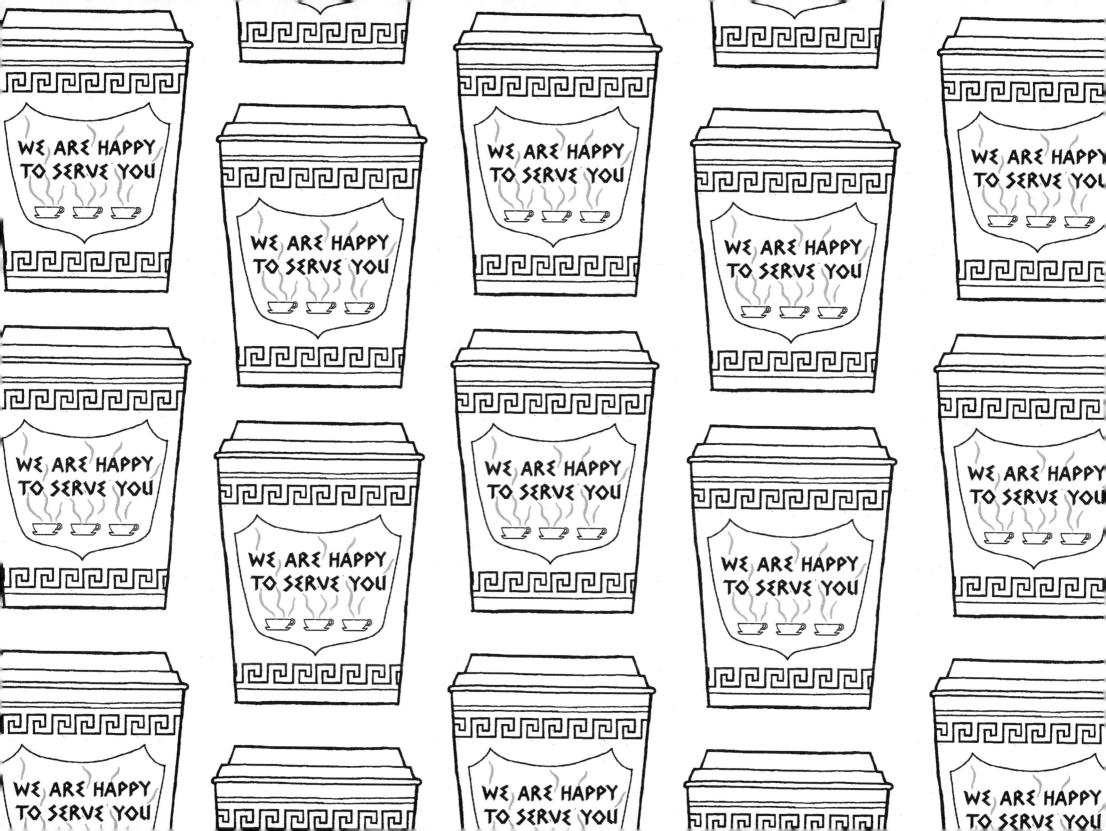

and the second s	

						¥	
		*					
	5						

W				

•	•		

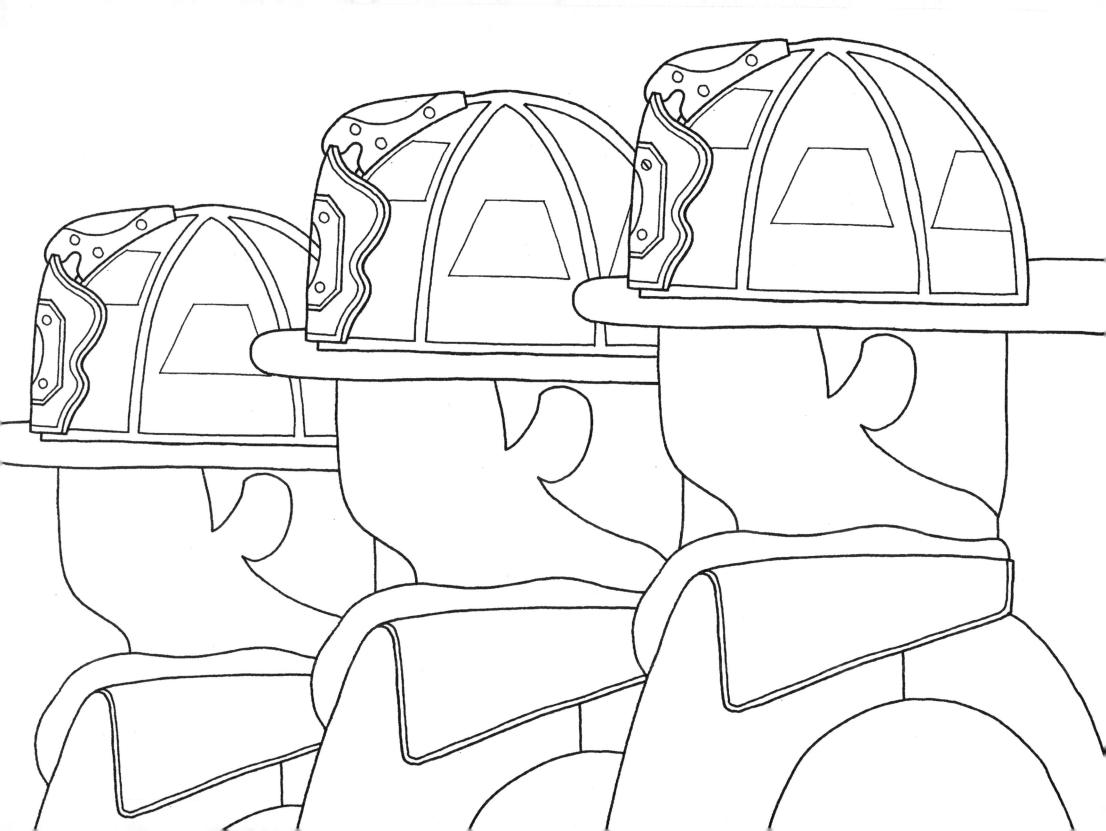

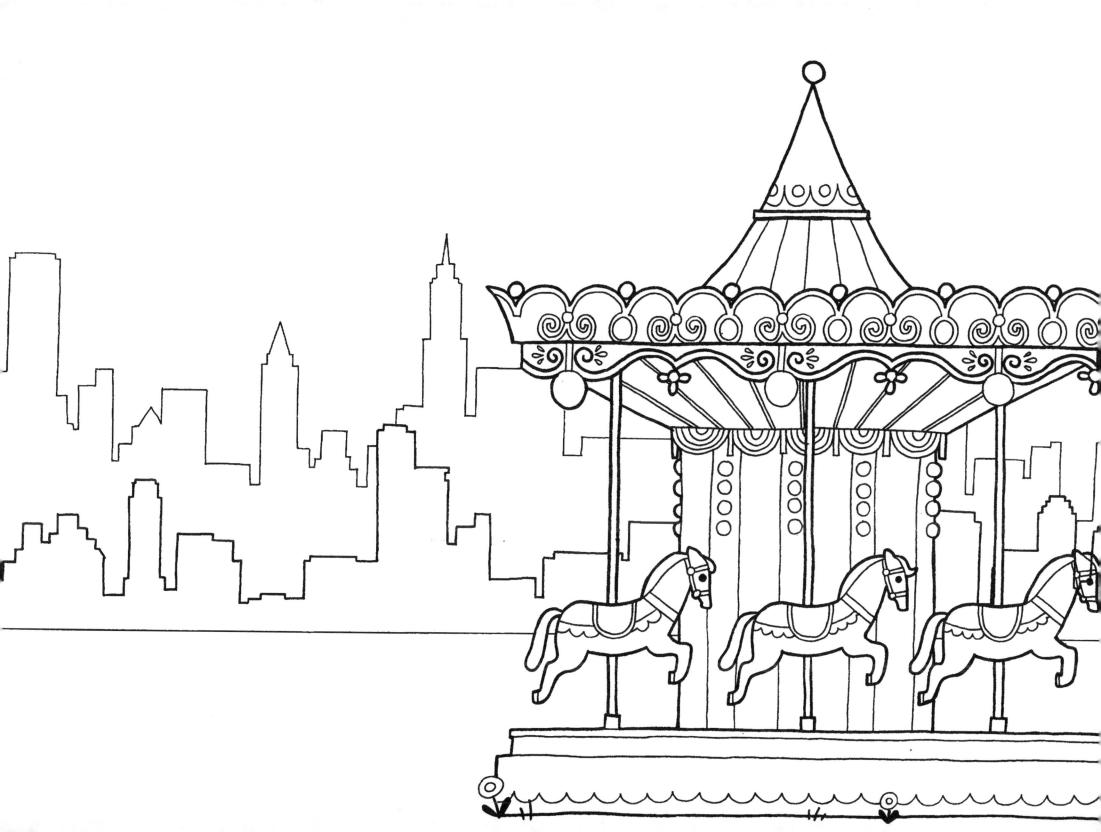

	-					
				ii.		

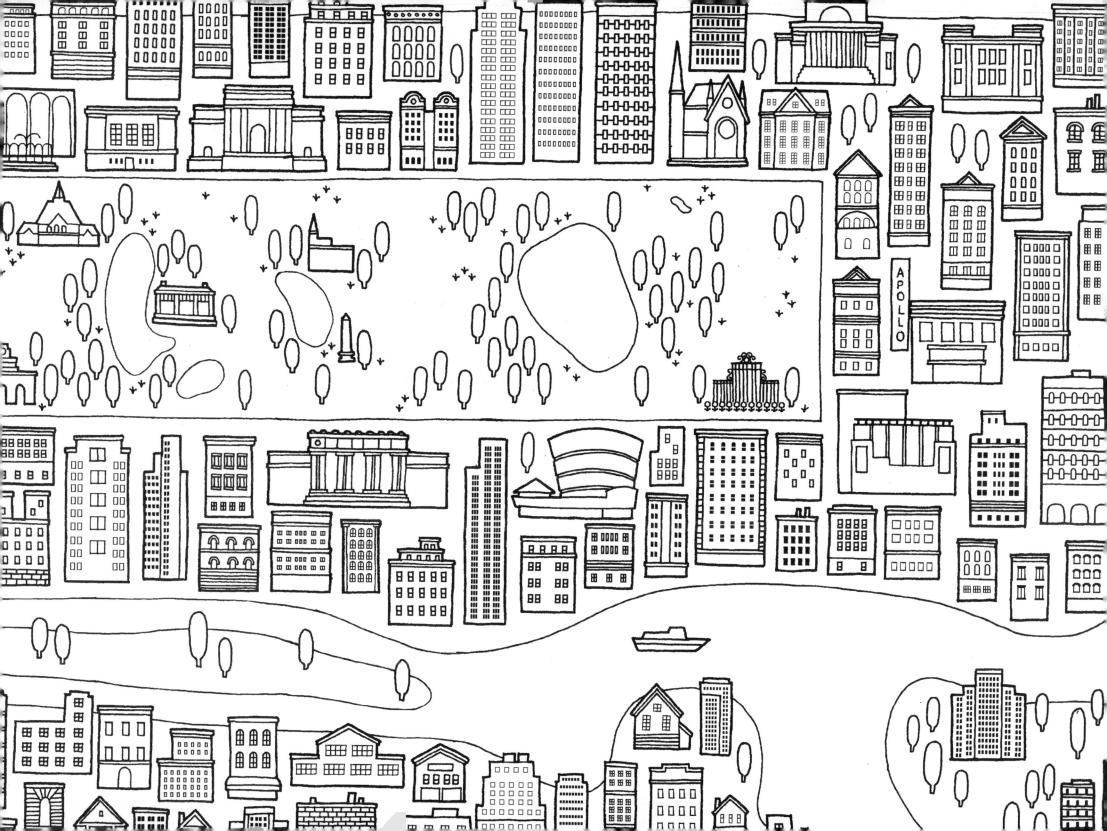

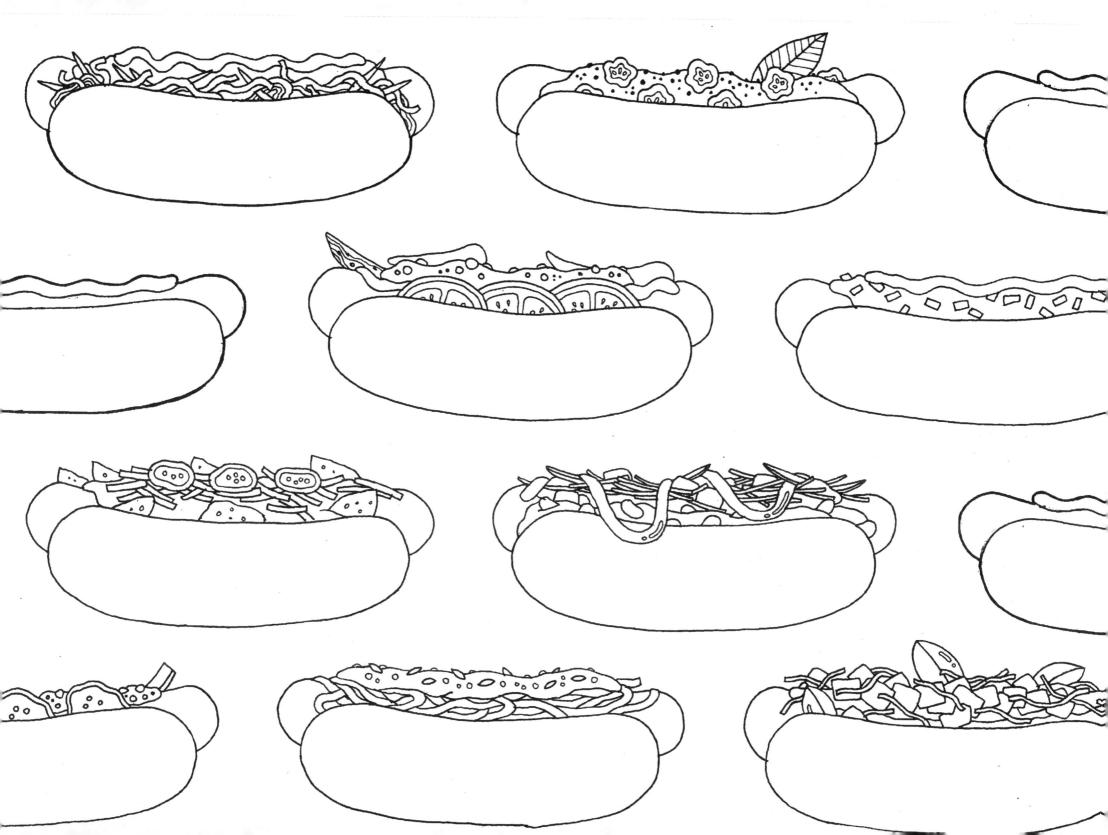

<i>*</i>				
	•			

CENTRAL PARK

					r

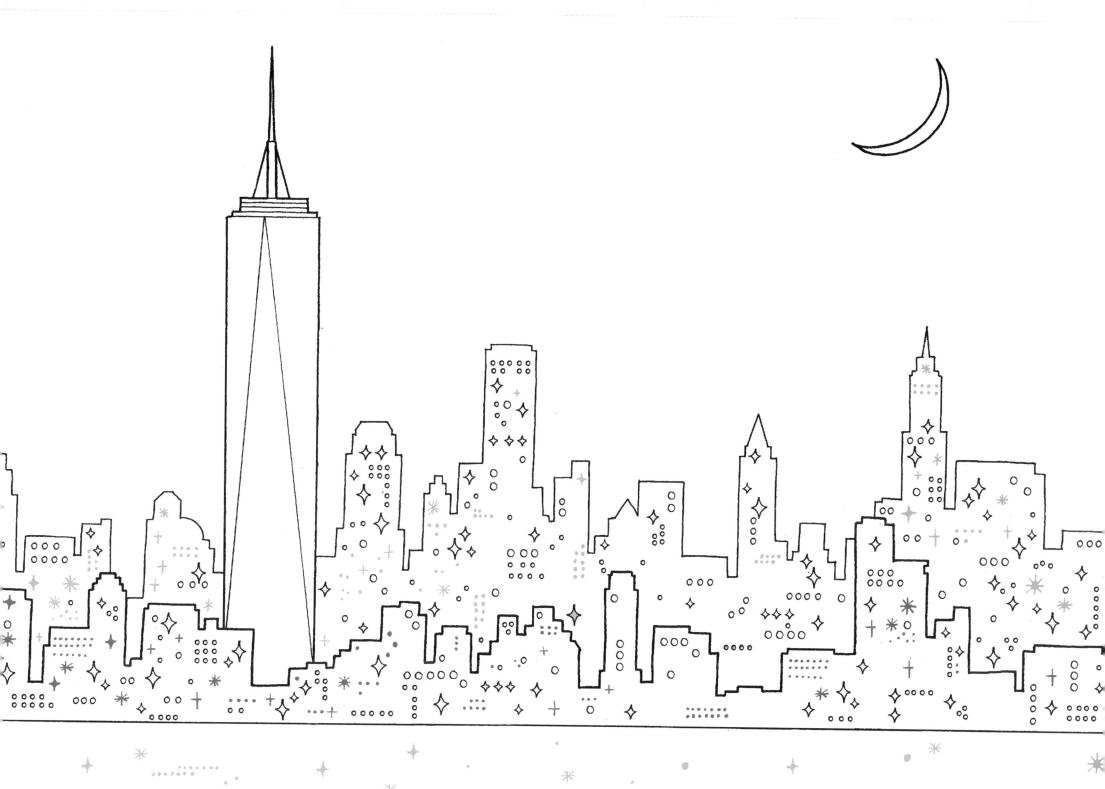

¥				

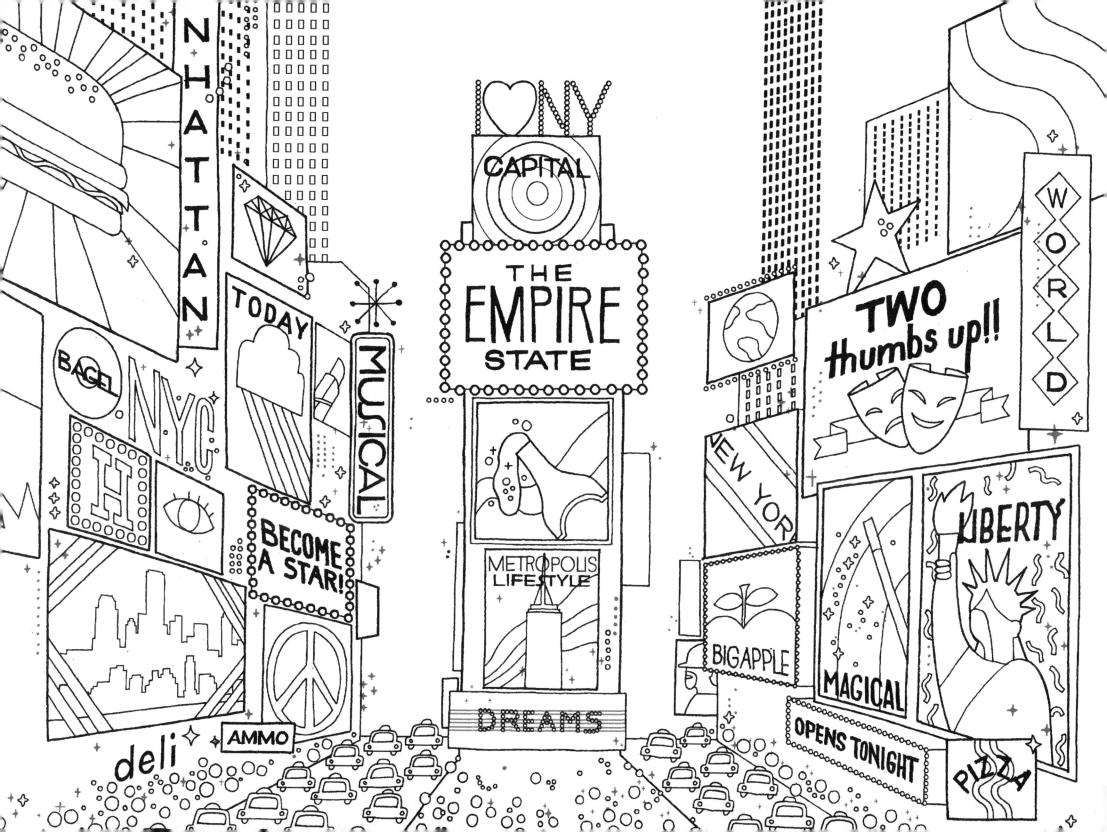

Ti di					
					,